BANKSY MYTHS AND LEGENDS

A COLLECTION OF THE
UNBELIEVABLE AND THE
INCREDIBLE

BY MARC LEVERTON

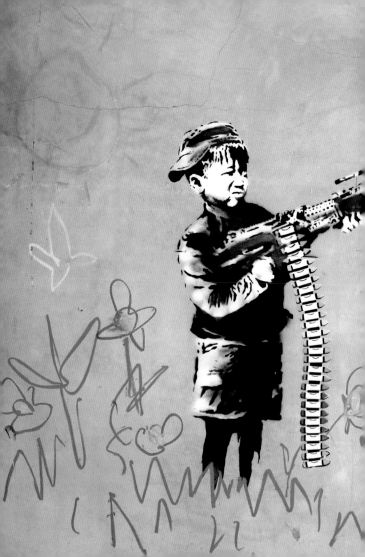

NO

PARKING

VIOLATORS WILL BE CITED
AND TOWED AWAY AT
VEHICLE OWNERS EXPENSE

**LAMC 80.71.4
CVC 22658A
LAPD 485-2121**

First published in Great Britain 2011
by Carpet Bombing Culture
email: books@carpetbombingculture.co.uk
www.carpetbombingculture.co.uk
ISBN 978-1-908211-01-9

Design and Artwork: Nick Law www.outlawdesign.co.uk
Additional images: Lord Jim, Annar_50, RomanyWG.

Thanks to: Richard, Nick and Mr B.

Dedicated to Charlotte, Edie and Myla

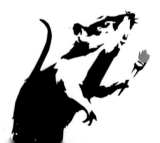

BANKSY MYTHS AND LEGENDS

A COLLECTION OF THE UNBELIEVABLE AND THE INCREDIBLE

BY MARC LEVERTON

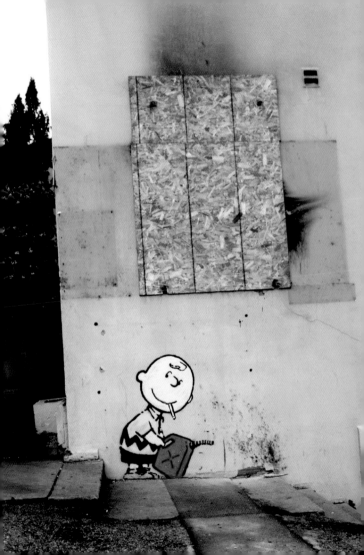

CONTENTS

'Use this to apply a measure of truth to the value of each story'.

Cock

Bull

Chinese Whisper

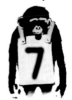

Careless Whisper

Wispa Gold

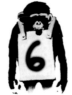

Taking the Myth

Pleading the 5th

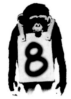

Honest M'lud?

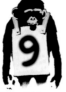

The Whole Truth?

Nothing but The Truth?

INTRODUCTION

No single living artist has created as many myths, rumours and legends as Banksy. In his home-town of Bristol almost everyone seems to have a Banksy story. Many of these stories are from Bristol, some are from further a field. What they share is that they are all told with that wide eyed wonder which Banksy inspires.

The stories were collected from people in Bristol between 2009 and 2011. Some are quite old and have been told so many times they have become the stuff of legend, others are more questionable and best described as myths. Some are laugh out loud bollocks and are simply gossip. You be the judge.

For me these stories illustrate the incredible audacity, originality and sheer bloody mindedness of Banksy. Obviously he should be best known for his art and exposing the many hypocrisies of modern life. The myths will be viewed as a distraction to some or part of the appeal for others. One thing is certain, the art and the myths are both larger than life and stick two fingers up at conformity. This book is a celebration of that anarchic, rebellious spirit.

Marc Leverton, Bristol, 2011.

BANKSY VS BRISTOL MUSEUM

Bloody vandals

During the sell-out 2010 Bristol Museum exhibition two of Banksy's iconic street art pieces in Bristol ('Hanging Man' on Frogmore Street and 'Mild, Mild West' on Stokes Croft) are vandalised. Blue paint is fired at them from a paintball gun. The fact that blue paint is used leads some to assume that the act was perpetrated by Bristol Rovers fans in response to Banksy's reported comment that Bristol Rovers 'play a dire form of the beautiful game'.

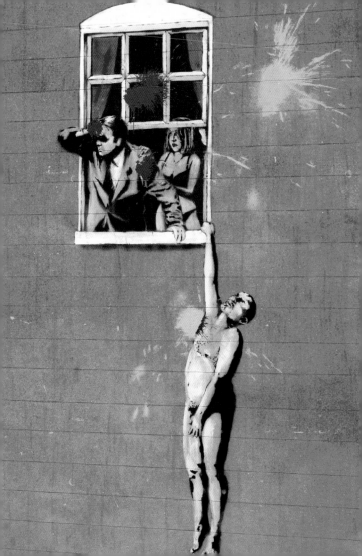

Lost warrants

Soon into the Bristol exhibition the rumour starts to circulate that the deal for the exhibition between Banksy and Bristol City Council only goes ahead if certain conditions are met. Banksy's old outstanding arrest warrants, pertaining to his graffiti work in the city must be 'lost' or revoked.

The secret entrance

During the show some of Banksy's work changes overnight, this is done without any of the local traders seeing or hearing anyone arrive or leave the museum. Rumours abound that Banksy has his own key to the museum and accesses the show in the dead of night. Even better is the assertion that he uses ancient tunnels that supposedly underlie the city and are controlled by a secret Masonic-like group of Bristol business people known as the Merchant Venturers.

Where's Banksy?

Banksy never set foot in Bristol, let alone the Museum, while the show was being planned. He masterminded the operation from his secret London HQ using video and a live webcam to plan the operation. He is in a bar in New Orleans on the night the show opens.

Banksy saves Bristol's arse

Council insiders claim there would have been a rise in Council Tax without the Banksy millions. Banksy earns Bristol £15 million and saves three jobs at the cash-starved Museum when the show hits town. At least 30 part-time jobs are created at the Museum as agency workers are brought in, local hotels and café's also see record takings.

I'm sticking with you

A volunteer at the Oxfam shop on Park Street almost loses thousands of pounds when they accidentally put a donated box out with the rubbish. These Banksy 'Neighbourhood watch' stickers were said to be brought in by the elusive artist the week before the show started. Initially they were thought to be worthless until the show started and they rapidly sold out eventually raising £15,000.

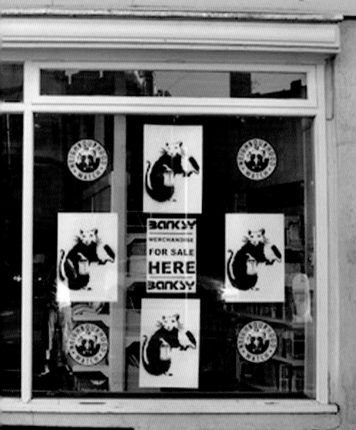

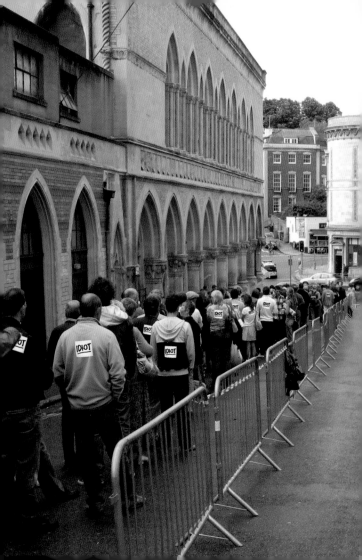

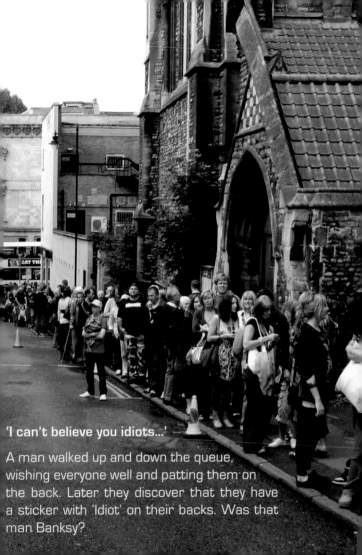

'I can't believe you idiots...'

A man walked up and down the queue, wishing everyone well and patting them on the back. Later they discover that they have a sticker with 'Idiot' on their backs. Was that man Banksy?

Banksy

Summer show opens 13th June

Details to follow

I really can't believe you idiots...

The show is kept secret, even from many of the museum staff. There are only three people within the Council that know about the event. Is the head curator sacked on the first morning of the event by senior bosses who are furious at being left in the dark? The story goes that she is reinstated within hours as the worlds media descends on Bristol and the cash tills start ringing.

Your name is not on the list

Eager Banksy fans try to gatecrash the private opening night party. One woman travels from London and puts £300 in the Museum donation box just so she can get in and rub shoulders with the invited guests who include Michael Eavis, Damon Albarn and Ian Brown.

Life imitates art

The show sparks off a series of Banksy-esque activity. On the first day alone 100 stencilled bits of cardboard are left on notice boards around Bristol, another 50 hand painted, numbered pieces are handed out to people in the queue. Weston-super-Mare's Andy Mclevey 'sneaks' a canvas of his own work in and is then featured in the Bristol Evening Post, Facebook etc. This is just enough publicity to be able to sell his prints for £100 each.

Cheeky artist ups
Banksy in his exh

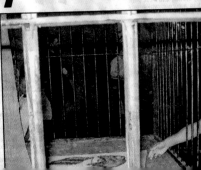

ONE of the problems with Banksy's new exhibition at Bristol Museum is that it's so vast and eclectic, it's hard to keep track of all the exhibits.

Weston-super-Mare artist Adam Mclevey realised this gave him the opportunity to devise his own guerrilla art event – all in the spirit of Banksy.

Adam decided to sneak his own artwork into the museum, and place it among the new Banksys.

But it's difficult to be covert when the piece in question measures 2ft by 3ft.

"I queued up and carried the painting in with me on the opening day," the 33-year-old said. "Amazingly, none of the security guards questioned the fact that I was carrying this big package into the museum.

"Once inside I made my way to the

Weston & Somerset **Mercury**

Established 1843 www.westonmercury.co.uk 25th June 2009 60p

n, 2009 WESTON & SOMERSET MERCURY www.westonmercury.co.uk

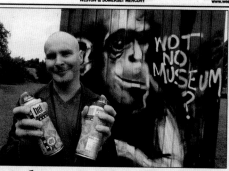

Adam joins Banksy

Report by **PIPPA CHAMBERS**
pippa.chambers@archant.co.uk

A CHEEKY artist from Weston has managed to sneak one of his paintings into the national Banksy exhibition in Bristol.

Adam Mclevey snuck his 24 by 36 inch canvas, depicting a monkey chained to a typewriter, in to the Bristol Museum on June 13.

The 33-year-old wrapped the painting up as a gift and when out of sight from security unwrapped it and slid it into a cage which formed part of the exhibition.

Staff at the museum soon removed it and to Adam's surprise they mounted it on the wall.

Adam said: "Artists have been doing it for years but it was my first attempt so I was totally gobsmacked that they decide to keep it in there.

"I was just hoping it would stay in for a day but now it has a place amongst Bankys' work which is brilliant. I later went in to ask if they could add my name to it but I am waiting to find out if they will."

Adam is also responsible for the latest graffiti piece in Castle Batch, off Magdalene Way, Worle.

He spray painted a monkey, with the caption 'wot no museum?' onto the shipping containers in the corner of the green.

He said the caption has many meanings but is linked to the uncertain future of the North Somerset Museum.

Adam said that artists need more legal space, such as the shipping containers, to display art.

To check out more art by Adam visit www.mclevey.com

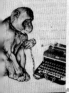

cil press officer Hele
"We would ask that pe
trying to copy this, be
going to create a lot of w
um staff at a time when they
dy have a lot on their plates."
either Banksy nor a spokesman
dam said: "I'm a big fan of Banksy,
available to comment yesterday
no harm to his work. If

Home sweet home

Homeless Jeffrey who sells The Big Issue can't believe his luck when the queue appears right next to his pitch on Queens Road. Struggling to keep up with demand his sales rocket and he is able to send some money back to his family in Jamaica. Recalling the event later he says 'I could do with a bit more of that, man. Bring back Banksy'.

UNIVERSI

This is not
a queuing
opportunity

This is not a queuing opportunity

A stencil that read 'This is not a queuing opportunity' appears on the wall of Browns next to the museum. It is removed shortly after the show closes. To their horror council chiefs later realise that they have removed a genuine Banksy stencil.

Y ROAD 8

Banksy banter

The queue for the exhibition is three hours long every day and visitor numbers top 300,000 over the 12 weeks of the exhibition. Museum staff are convinced that Banksy joins in the queue on more than one occasion to listen in on the Banksy banter.

99 problems but my pitch ain't one

As the queue started to take on a life of its own,
so did the rumours. The ice cream van pitch at the
top of the queue (not to be confused with Banksy's
ice-cream van which was used as an information
booth during the show) was said to be auctioned
off by the Council to the highest bidder. An ice
cream man bidding war ensued. The winner then
worked 12 hours a day for the entire 3 months
of the show. Apparently 99s with a flake were his
best seller.

WHO IS BANKSY?

Banksy was my goalkeeper

Bristol footballers claim that Banksy gained the name after playing in goal for them. The team were each assigned a nickname after great footballers and Banksy's goal keeping prowess earned him the name 'Banksy' after the legendary England keeper Gordon Banks. This story must be true because it was told to us by Nobby Stiles.

Banksy is from Yate

Banksy is the son of a photocopier technician and a nurse and was brought up in Yate in South Gloucestershire. Yate was rated the 45th Crappest Town in Britain in The Idler Book of Crap Towns.

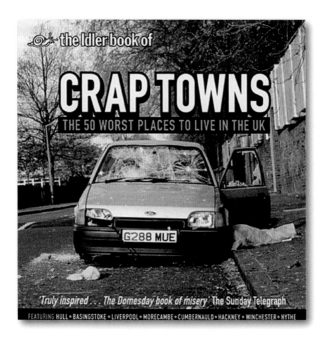

Meat is murder

Banksy trained as a pork butcher on a government scheme for young unemployed people. His experience as a trainee butcher turned him vegetarian and his later work would focus on the plight of animals in zoos and also the fur trade.

The Mail On Sunday claimed in 2008 that Banksy was a ginger, speccy, rugger-bugger, public school boy from Clifton and was the son of an accountant. Banksy supporters protested that he wasn't ginger.

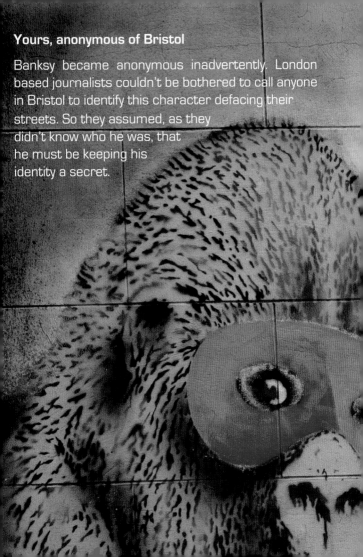

Yours, anonymous of Bristol

Banksy became anonymous inadvertently. London based journalists couldn't be bothered to call anyone in Bristol to identify this character defacing their streets. So they assumed, as they didn't know who he was, that he must be keeping his identity a secret.

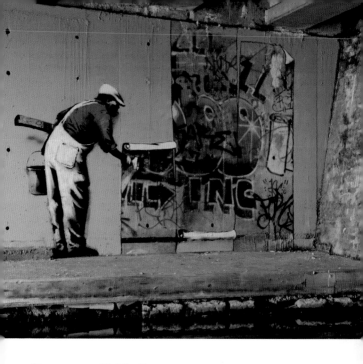

Batman or Robbo?

Banksy's real name is Robin Banks, or is it Robert Banks? Another crazy theory is that Banksy is one and the same as long-time graffiti legend Robbo. Speculation arose when Banksy painted over one of Robbo's seminal works on Camden Canal and the graff code of conduct dictates that artists only ever paint over their own work.

Graffiti by committee

Banksy doesn't exist, there is no Banksy. 'He' is simply a name put forward by a group of artists who conspire together. An old theory is that this could include any mix and match of street artists from the Bristol scene. Another theory is that Banksy is a collective including someone in a wheel chair, a red-haired woman and a bloke with abnormally big hands. In 2010, Banksy is seen in Detroit with 15-20 people on a roof. They order take away pizza while a new piece is executed.

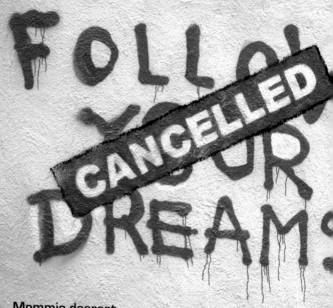

Mommie dearest

Banksy's Mum didn't know that her son was the world's most famous artist until the Mail on Sunday started sniffing around in their failed attempt to unmask Mr B. She thought he had been working as a painter and decorator since moving to London in 2000.

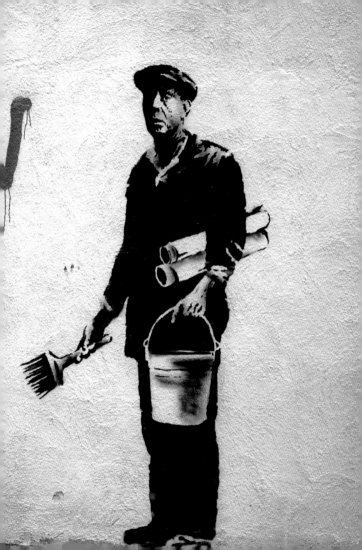

Cider I up

Banksy's rural hideaway is a farm in deepest Somerset. Like most people from the West Country, he enjoys a drop of scrumpy and put up a piece in Roger Wilkins' cider barn while enjoying a few pints. This rare Banksy cost Rog Wilkins 5 gallons of Farmhouse Dry.

Cider I up some more

Banksy paints a friend's stall front at the Ashton Court Free Festival in the late 90s and is paid in cider. Eight pints of farm strength scrumpy later, and Banksy was barely standing but felt like he had drunk his money's worth. The piece was kept by one of the festival organisers and was later auctioned for a six-figure sum.

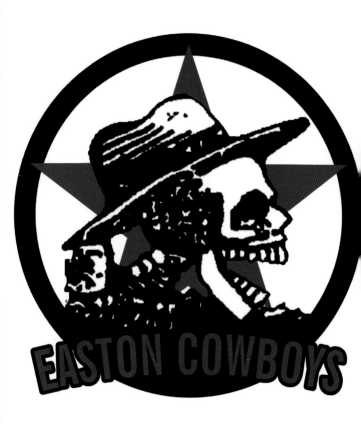

Ride 'em, cowboy

The Easton Cowboys, a group of radical footballers in Bristol plan a fundraiser for water projects in Mexico. Banksy donates an original canvas of a footballer doing a scissor kick. The Cowboys print T-shirts of the artwork and sell them for £5 each, including some horrible pink ones that nobody buys. The original is raffled off through a record shop called Eat the Beat.

The Cowboys, realising Banksy's work is increasing in value hatch a plot to buy up all the tickets to the raffle and auction the painting at a later date. They dispatch two cowgirls off to town to carry out the dastardly deed, but they get cold feet on the way and decide not to go through with it. The genuine winner bought a single ticket for £1. What happened afterwards is revealed on the next page.

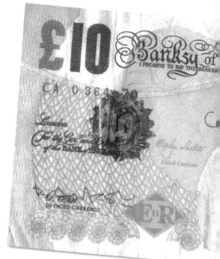

Banksy for a squid

A woman from South Bristol wins the Eat the Beat raffle. The painting is delivered by someone she assumes is Banksy because he talks to her about the painting.

A few years later she sells the piece back to Banksy's manager for £15,000. He also gives her a Banksy book and a Princess Diana banknote in exchange. Unfortunately, she used it as a bookmark and then forgot which book it was in. It has not been seen since. Oh well, easy come easy go, at least the cash enabled her to pay off her debts and go on a nice holiday to Cuba.

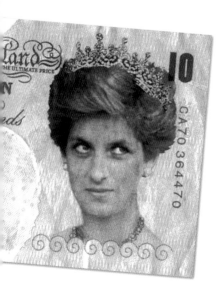

Money makes the wheels go around

Banksy often made his get-away on a push bike after putting up pieces. Needing a clean pair of wheels, he regularly had his bike serviced and paid for it in prints and canvasses thus creating Britain's richest bike mechanic.

A jumper's not just for christmas...

The Greenleaf Bookshop (a now defunct independent radical bookshop on Colston Street in Bristol) sells Banksy's first set of prints for £60 each. They put them in the window. 15 years later almost everyone can remember them and why they didn't buy them. '£60 seemed like a lot of money for an art print back then' says Charlotte, who nearly bought one for her boyfriend for Christmas but bought him a jumper instead. 'It was a really nice jumper', she adds.

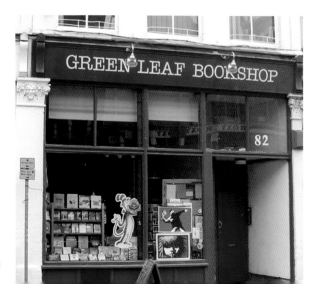

Sold down the moon river

The landlord of The Full Moon on Stokes Croft in Bristol realises he may be sitting on a fortune in the form of a small Banksy stencilled on the wall of his pub. It is amongst the very first of Banksy's street works and is potentially a historic document.

'I owned the wall, and I needed the money,' he says. The piece was briefly on display in St Nick's Market in Bristol before being shipped off to foreign climes.

Flowers that just keep on growing

A young Bristol student gets all his pennies together to buy a print of Riot Green from Banksy's first big Bristol show at the Severnshed. He buys the piece for £250, and sells it for £25,000 ten years later. A handsome profit by most people's standards. Within a month the piece has resold for £180,000. Today it is estimated to be worth upward of £250,000.

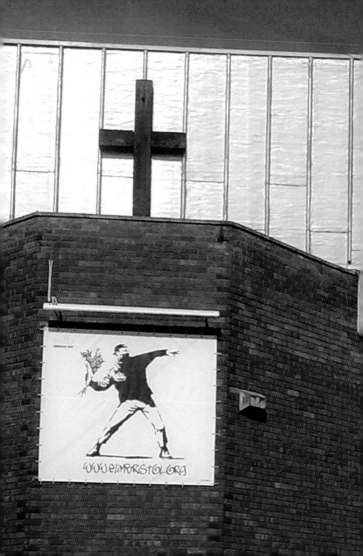

Anarchy, Capitalism and Democracy in action

In reponse to the Anti-Tesco riots in Stokes Croft Bristol in 2011 Banksy releases a limited edition of 2000 prints of a Tesco value petrol bomb. The prints are sold at Bristols Anarchist Book Fair on a strictly first come, first served basis.

The queue is mostly genuine Banksy fans, but amongst their midsts are many speculators. Including middle-class investment opportunists, foreign gangsters and homeless ex-cons hoping to make a quick profit.

Prints take minutes to appear on Ebay, thanks to the Ebay iPhone App with a starting price of £145.

Banksy's efforts make a quick £10, 000 for the Peoples Republic of Stokes Croft who use the money to help squatters made homeless after being evicted from Telepathic Heights where police believed petrol bombs were being made on the night of the riot.

What are you for?

The list of celebs owning Banksy's artworks could make up their own edition of Hello magazine. Brad, Jude, Christina, Kate, Prince William, Simon Cowell blah blah blah. But did you know that Macaulay Culkin boasts a Banksy? And the Dalai Lama? OK, not the Dalai Lama but Culkin is a cert.

Now you see me now you don't

An early Banksy piece was completed using UV paints on the bedroom wall of his manager's house in Easton, Bristol, close to this other disappearing tag (pictured). It could only be seen using UV light and the owner has since moved on. This means that someone has a unique artwork hidden under the wallpaper.

The party's over

During the Mayor of London election campaign of 2008 Banksy donated artwork to raise funds for Ken Livingstone and The Labour Party. Unfortunately, due to strict fundraising laws Banksy's anonymous status meant the party were unable to accept the donation, which initially raised nearly £200,000.

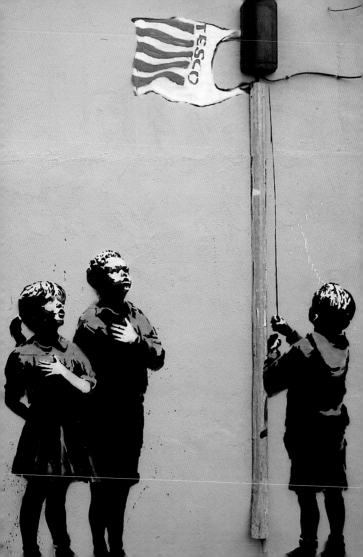

Stink tank

The lovers in divers' masks which graced the Blur Think Tank cover in 2004 was also stencilled onto a door in Deptford, South London. The door was cut out and sold for £8,000 by 'two pikeys'. Despite efforts by Pest Control, who will not verify any of Banksy's street work, the piece continues to be re-sold.

DIY SOS

An early associate of Banksy was doing some DIY and thought his original painting of Riot Green would make the perfect surface for mixing some plaster. The myth goes that ten years later this associate is still rueing his 'DIY disaster' and is slowly trying to restore the piece to its former glory.

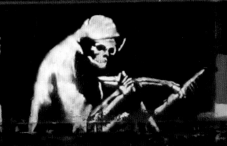

Row, row, row your boat

Banksy loves boats, he often uses rowing boats to get to hard-to-reach spots over water. An early piece on Pero's Bridge in Bristol was removed by the Council in less than six hours. Despite being in a spot accessible only by boat. Obviously hit a nerve there.

Graffiti wars

The owners of the Thekla nightclub on a boat in Bristol docks threatened to take the Harbourmaster to court for unauthorised criminal damage after he removed a Banksy tag from the side of the boat. Banksy responded by returning by boat and replacing the lost tag with this Grim Reaper image.

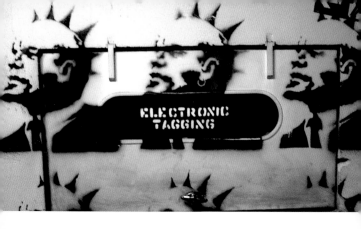

The truth is out there

As well as the many 'lost' Banksy's there are also many 'hidden' Banksy's which periodically surface. A well-known example is the Swiss Embassy car park which is featured in a Guardian video (not that hidden then).

But there are also rumoured to be works:
- stashed away in a car park in Amsterdam.
- a garage in Kingswood, Bristol with practice tags of Banksy's, said to be in his old house.
- the studio basement of Massive Attack's Daddy G in Montpelier, Bristol.
- the old Birmingham Bullring.
- various youth clubs around Bristol, including Barton Hill and Lawrence Weston.
- a duck farm up north for a Blur Think Tank photo shoot.

Buried treasure

Lez Hutchins was a much-loved Bristol club promoter who died suddenly after contracting flu. Her coffin was provided by Heaven on Earth a Bristol-based natural burial company. Banksy decorated the coffin. It isn't known what design he used but this piece is located next door to the shop.

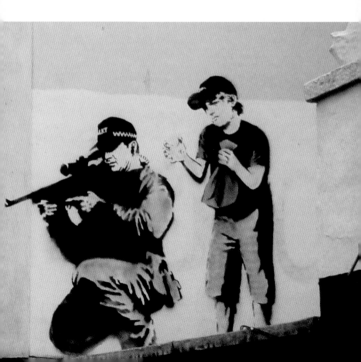

Skipping dopes

Venue magazine supposedly had some of Banksy's prints in frames on the walls of their offices in the late 90s. When they moved offices, they chucked them all in a skip getting ready for a new start. Whether anyone retrieved them is unknown.

Banned from the bus

The number of protesters on the Stop the War march in London in 2003 was said to be close to one million. A small number of them were given hand-made banners by some cheeky so and so, who kept himself hidden by a mask. Was it him? The banners were certainly his work, they proclaimed 'I don't believe anything. I'm just here for the violence'. Unfortunately, those who had made the trip to London by coach were forced to leave them behind by job's worth coach drivers who didn't want any 'trouble'.

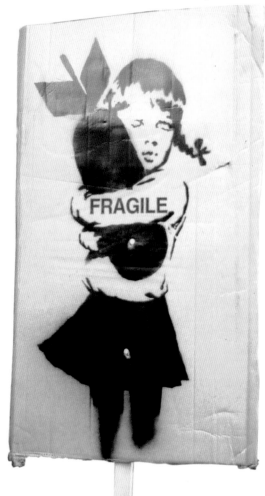

320 Bath (A4)

M 32 City Centre

Some people say I'm Bonksy

The M32 motorway comes right into Bristol through the heart of Banksy territory, Easton on one side, St Pauls and Montpelier on the other. The grey bridge spanning the motorway was hit with a giant 'Banksy' tag overnight. Unfortunately, as the work was executed upside down the resulting work reads more like 'Bonksy'.

A statement is issued to the Evening Post categorically denying the work as being by Banksy. Rumours circulate however that it was indeed Banksy, but slightly worse the wear after a night on the cider.

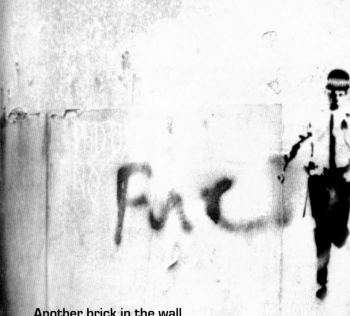

Another brick in the wall

Banksy was expelled from school, the story goes that he and another mate swung a kid round by his legs and then dropped him on his head. Banksy claims he was in fact innocent of the crime, but was expelled anyway. Does this explain the Banksy themes of social justice and persecution of the innocent?

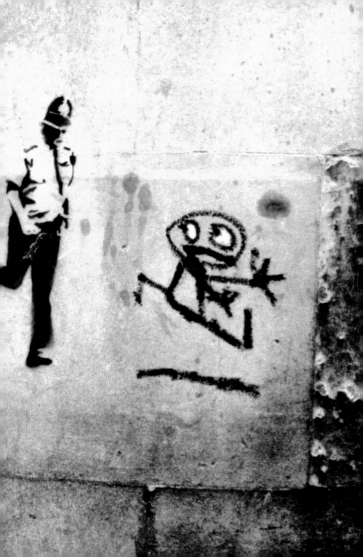

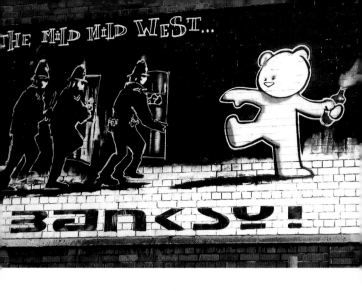

New age Banksy

This iconic 'Mild, mild west' piece was voted the cities favourite alternative landmark in a BBC Bristol poll. An early illustration of the piece shows a teddy bear smoking a spliff which was changed to a Molotov Cocktail at the last minute. The myth is that the piece is a comment on the infamous St Paul's race riots which happened nearby in the early 1980s. Closer to the truth is that the teddy bears represent new age travellers who were harassed to near extinction after the Criminal Justice Bill.

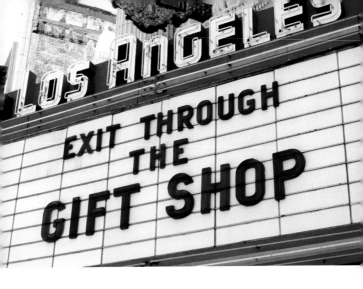

Edit through the gift shop

Mr Brainwash, aka Thierry Guetta is the street artist credited with filming Banksy and helping create the first 'street art disaster movie'. What isn't so widely known is that Banksy had no interest in making a film until he saw the rushes which threatened to blow his identity. So Banksy bought all the material from the artist for an undisclosed sum on the understanding that he would have it edited and re-filmed to conceal his identity once more.

Animal farm

Hiding in a bush from Spanish police in Barcelona Zoo, Banksy hears footsteps and realises the game is up. As he turns to face the armed police what he actually comes face-to-face with is a kangaroo. In celebration he lights a cigarette, only to set off a sprinkler soaking himself and the Spanish translation of 'Laugh now, but one day we will be in charge' which was on a piece of paper in his pocket. Not wishing to insult the Spanish by using English he settles on the classic prison 'counting days' graffiti.

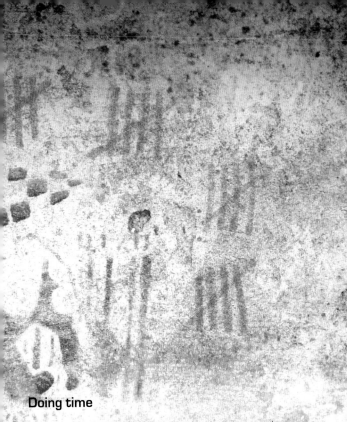

Doing time

In the early stages of Banksy's career he was arrested for defacing a billboard. He was punished with community service, and fined. This myth may have morphed into the later myths of 'Banksy did time' which have circulated ever since and were perpetuated in a famous Guardian interview with Simon Hattenstone.

Spot the Banksy

The People's Republic of Stokes Croft is a movement of Bristol based DIY artist activity designed to make a previously grotty run down area of the city into something beautiful and inspiring. During Banksy's Museum show they give punters in the queue blank cards to graffiti, doodle or write insults on.

The collection of these drawings were then exhibited and published as 'The Banksy Q'. You think the myth is going to be that Banksy drew a piece for this book. Well, you will have to buy the book for yourself and see if you can spot which one might be by Banksy.

PRSC

THE **BANKSY Q**

by
Katy Bauer
for the
People's Republic
of Stokes Croft

Location, location, location

A couple in Easton in Bristol had the idea of selling their Banksy – with a house attached. So for £150,000 you could own a full wall of Banksy and get a free 3-bed end of terrace. Apparently word reached Banksy, who was so outraged, that he defaced his own work to prevent such a blatant cash-in.

Location, location, location, location

During the Noughties, the redevelopment boom means that property speculators are trying to squeeze a profit wherever they can. Several street pieces from Banksy fall victim to over zealous builders including 'Abi's Piece' in St Werburghs, Bristol and a Bansky rat in Belsize Park, NW3. The irony is of course that it would have been quicker and easier to make a profit by selling the artworks rather than stripping some floorboards and painting the walls magnolia.

Dedication's what you need

After a drunken bet with another well-known British artist Banksy tries to get his name into the Guinness Book of Records by attempting 'Britain's longest painting'. The finished piece spans the borders of Ladbroke Grove and Notting Hill. An extremely long white line trails from the nose of a copper down a street, up some stairs, around a café before disappearing down a drain.

Unfortunately, all record attempts need to be verified by the Guinness Book of Records which means proving your identity.

Man walks into an STD clinic...

The Frogmore Street 'Hanging Man' image on Park Street Bristol has courted a lot controversy in its lifetime. it is on the side of the sexual health clinic it has long been assumed that the piece is comment on its clientele. actual fact, if there is such a thing in this book, the man hanging out the window is said to be an ex-associate of Banksy who had been having it away with 'Banksy's wife' ie his art.

Faking it

A rogue Banksy documentary is floating around the internet, being publicised by fakes of Banksy's fake Diana £10 notes. The latest rumour is that Banksy needed to fake the money after losing all his fortune to a scam involving setting up a street art project in the Middle East.

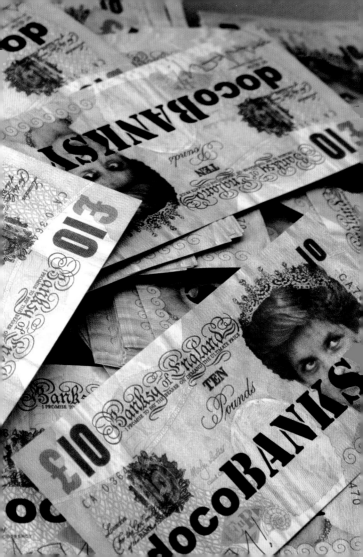

This little Banksy went to market...

According to his website (banksy.co.uk) 'Banksy does not endorse or profit from the sale of greeting cards, mugs, T-shirts, photo canvases etc. Banksy is not on Facebook, Myspace, Twitter or Gaydar. Banksy is also not represented by any form of commercial art gallery'.

This means that he isn't pocketing cash from all those ludicrous exchanges in what is called the 'secondary market' ie galleries to super rich celebrities (or entertaining little humour books). So he isn't as rich as you think he is.

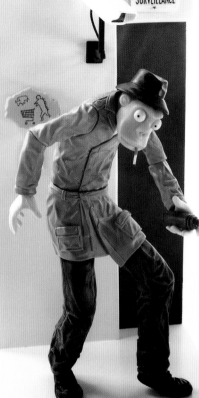

YOU ARE UNDER SURVEILLANCE

THE ART ARMY®

BANKSY

9 POSABLE PARTS. THE KING GUERILLA ARTIST. w/ PIRATE MUSEUM HANGING.

Action man

Seattle-based artist Mike Leavitt has created a couple of Banksy figurines which depict Mr B 'at work'. The 11-inch figures have 23 moving parts. He also does a cool Damien Hirst which is cut in half like his shark. Who needs myths when the truth is this entertaining?

intuitionkitchenproductions.com

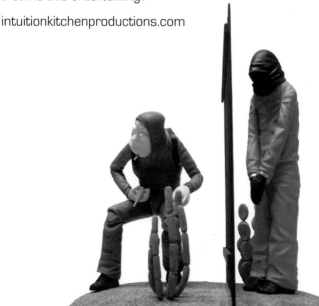

Paranoid pictures

In the first weekend of release 'Exit Through the Gift Shop' grosses $170,756 in the US and £81,000 in the UK. A remarkable achievement given that the film is given a limited release, distributed independently and is only marketed using social media.

In the next few weeks the film goes onto gross $1,950,348 in the US and £316,326 in the UK and is also widely given rave reviews from critics from Berlin to Boston.

Banksy does some 'promotional' stencils in various US cities to commemorate the event. Many of which are removed within days, which goes to show that Banksy can still get up the noses of the powers that be.

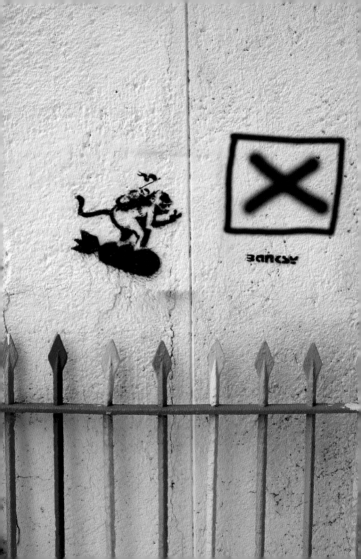

Vote Banksy

In 2006 Bristol City Council allowed members of the public to vote on whether the Frogmore Street 'Hanging Man' should stay or go and 96% voted in favour of keeping the piece.

In 2009 members of the public in Croydon, South London were invited to do something similar with regards to the Ikea Punk piece on Beddington Farm Road. The public voted 93% in favour of keeping it, but the piece was defaced by taggers and then yanked out by some blaggers.

In a poll of 18 to 25-year-olds, Banksy was ranked young adults' third favourite "art hero" after Walt Disney and Peter Kay. Fourth was Leonardo Da Vinci and fifth was Bob Marley.

 Number of album covers on which Banksy's work has appeared.

 Film certificate for Exit through the Gift Shop. Closer inspection reveals 'Mental Age'

 Banksy's age in 2010

 Ranking of Banksy's alleged birthplace Yate in the Idler list of the Top 50 Crap Towns in the UK

 Pounds that Banksy's Princess Di tenners go for on eBay

 Proposed length in kilometers of the Israeli wall around occupied Palestinian territories. Banksy first painted the wall in 2005

People who attended Banksy vs Bristol Museum over the first weekend of the show in June 2009

Pounds that the Whitehouse pub in Liverpool fetched at auction. The side of the building has an image of a giant rat by Banksy

Record price for a Banksy. Space Girl and Bird fetched this at auction at Bonhams on April 27, 2007

People who attended Banksy's show at Bristol Museum over 12 weeks making it the 30th most visited show in the world for 2009

Results you get if you Google 'Banksy'

IF GRA

CHANGED

IT W

BE IL

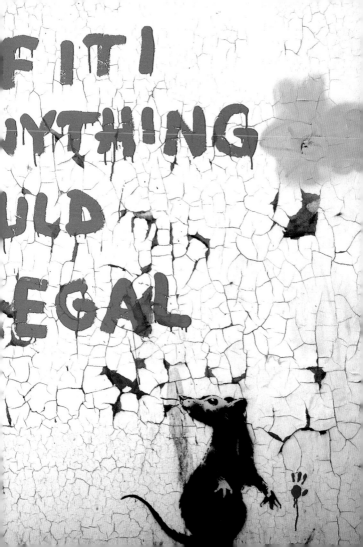